D1266098

PARADISE STREET

In the series *Vintage Britain*

BOOK ONE

The East End in Colour 1960–1980

BOOK TWO

The Isle of Dogs

BOOK THREE

Dog Show 1961–1978

BOOK FOUR

Paradise Street

PARADISE STREET
THE LOST ART OF PLAYING OUTSIDE

With photographs by

Shirley Baker, Tony Boxall, Robin Dale, John Gay,
Henry Grant, David Lewis-Hodgson, Paul Kaye,
Roger Mayne, Margaret Monck and Martin O'Neill

HOXTON MINI PRESS

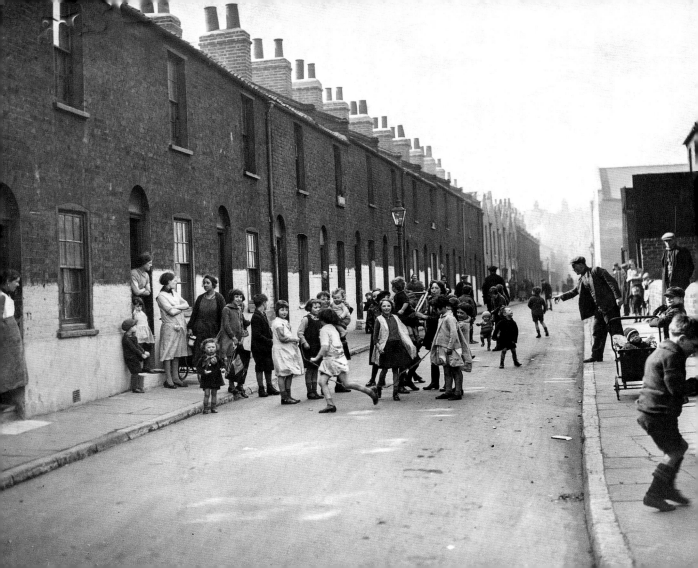

INTRODUCTION

Growing up was different in the middle of the 20th century. Britain was different. Not always better; but different. Cars had something to do with it – there simply weren't that many. Not everyone owned a car, especially in the inner city and they were at least infrequent enough for someone on look-out to yell a warning so that kids playing in the road could scatter to the safety of the pavement. Because that's what most children did. They played outside.

Although memories may be coloured by rose-tinted spectacles, an older generation – baby boomers and the baby boomers' children – fondly recall long summer afternoons playing outside until the sun faded, or the call came to come in for tea. They experienced a childhood growing up in the open air, with more time spent outdoors than inside. Kids of the seventies might have raced on bikes round cul-de-sacs, or clattered along pavements on roller skates. Their mums and dads remember chalking hopscotch squares on the ground or rattling tin cans while others ran to hide.

Babies sat throne-like in prams, parked up in the 'fresh air' outside front gates, watched over, perhaps, by an older sibling. Dolls, footballs and skipping ropes made it out onto the street, but playthings were just as likely to be found to hand in immediate surroundings. Children were adaptable and found opportunities to play with sticks, puddles, an old door to make a den, an abandoned car or mattress, a pit town's slag heap, a mountainous pile of road chippings, a vertiginous wall to clamber up, or a football pitch in an abandoned brickworks. And for those growing up in the aftermath of the Second World War, the rubble and ruin of bomb sites, expressly forbidden by parents, proved too strong a temptation for curious kids keen to explore.

Did they really have it so good or are these recollections the result of deeply saturated nostalgia? Comparisons with today's children do not favour the 21st century generation, who are reported to be addicted to phones and games consoles, spend most of their waking hours indoors, and whose diet of

junk food is apparently contributing to an obesity epidemic. Playing out tends to be in a safe space, a playground or sports ground, watched over by parents or carers; the streets are too choked with traffic to offer a viable alternative. But for many children growing up 40, 50 or 60 years ago, playing outside was a daily norm, often done because they simply had nowhere else. Terraced houses had only cramped backyards to accommodate the overspill of energetic children. Mothers sent their offspring through the front door, out from under their feet, to play on cobbles, in back alleys or on pavements, knowing their own children would be playing with others from the same streets, those they knew; a close community. For many children growing up in the 20th century, the street was their playground.

Allowed to roam free, to run, jump, imagine, fight, chase, whisper and plot, children formed their own rules and networks. Robert and Iona Opie, who studied the traditions of childhood and play in the 1950s and 60s, observed that children in Britain had developed a culture of play in which the games were passed on through the generations, and, free of adult intervention, the rules and disciplines required to coordinate and cooperate in these games equipped children with valuable skills for adult life. These were progressive ideas but half a century before the Opies' studies, philanthropic types also believed in the benefits of play, though through more controlled adult supervision.

'No sight in London is more piteous than the children of the slums playing in the streets and alleys of the huge Metropolis,' wrote Dr Alice Johnson in *The Review of Reviews* in 1899. Johnson, who believed that children living in areas of the East End did not know how to play, was President of the Children's Guild of Play in Canning Town. From its headquarters in Barking Road, the Guild sought to provide structured play opportunities and to teach 'old English games which embody in quaint fashion many of the customs and practices of bygone days'. The Guild, along with other well-meaning organisations such as the Children's Happy Evenings Association, set out to take children off the streets and to teach them the 'right' way to play. There was a clear distinction between 'good' and 'bad' play and the latter was largely an urban problem. Mary Lennox, the spoilt orphaned girl with the sallow

complexion in Frances Hodgson Burnett's 1911 novel *The Secret Garden* is sent out alone each day to play in the gardens of the Yorkshire stately home of her uncle, and is subsequently transformed by 'the big breaths of rough fresh air blown over the heather' after her sedentary life in colonial India. In contrast, city children were exposed to the unsavoury elements of urban living, meaning that in their case, playing outside might have quite the opposite effect, though one East End doctor, writing in 1913, claimed 'the child who can survive the first year of slum life, who can live long enough to toddle out of the stuffy room into the street must have a constitution of iron'.

If it was survival of the fittest on the streets of Edwardian London, then there were plans afoot to improve the environment for children. Councils were encouraged to make school playgrounds and fields available for children after hours. Play Centres and 'Play Rooms for Poor Children' provided the same sort of recreation as youth clubs would in later decades. In 1927, it was still estimated that four million children in Britain were without playing fields. The National Playing Field Association, headed by the future King George VI and later by the Duke of Edinburgh, was formed to address the issue. In the post-war years, as British cities began to rebuild, much cramped and inadequate housing would be replaced by inner-city estates and modern suburban housing. Planners and architects created playgrounds; houses came with modest gardens, but during this slow evolution, the natural inclination of children to play out on the streets, and to make their own amusements, never disappeared.

Writing in *The Observer* in 1961 under the title, 'The private world of children's games', the Opies asserted, 'It is not true that children's interests are now confined to space comics and pocket money.' They advocated that children left to their own devices were far more likely to develop qualities of perseverance and self-discipline, unlike those who had their 'free time organised for them'. 'The more they have equipment provided, the more they lose the traditional art of self-entertainment,' they reasoned. Half a century later, the same argument continues.

It is significant that the photographer chosen to provide images to illustrate the Opies' article was

Roger Mayne. Mayne had a long and varied career as a photographer but his images of the communities of Southam Street in North Kensington taken between 1956 and 1961 set a standard of street photography in Britain. Central to this body of work are the children in the area, most frequently captured absorbed in play – kicking footballs, playing cricket, competing in sword fights, dancing together, swinging from lamp posts, pushing old prams, steering rickety go-karts or pummelling each other in a fight, seemingly unaware (or uncaring) that their activities were being photographed. A selection of photographs by Roger Mayne are included in this book, alongside work by photographers who followed in his wake and recognised that street play offered endless opportunities to create spontaneous, unguarded and prescient images of local urban communities, documenting a moment in time before economic, architectural and social shifts changed this habitat forever.

Shirley Baker roamed the streets of her native Salford as terraced housing was being torn down and local children continued their games regardless of the encroaching bulldozers. In Balham, South London, Paul Kaye's pictures of neighbourhood kids in the early 1960s offer a charming evocation of the tightly-knit friendships that grow from living in close proximity to each other. Robin Dale photographed kids whose curiosity and camaraderie shine brightly against the disintegrating industrial landscapes of 1970s Middlesbrough and Teesside, while Martin O'Neill, as a young photographer in Eccles during the late 1970s and early 1980s, gives us a portrait of a generation growing up in Thatcherite Britain.

Binding all these images together is a common thread; one that has begun to unravel in more recent times. The children and young people in these pictures amuse themselves with little more than a handful of toys and raw materials, their environment, imagination and one another. Friendships and rivalries ebb and flow in this unsupervised arena but the images crackle with energy and joy. They live in a different world; often one of poverty and hardship, but also of inventiveness, imagination and freedom, and there is a sense that they enjoyed a richer formative experience than kids of today. Perhaps we can all learn something from their adaptability and appetite for life. Most of all, here are

photographs that form a thought-provoking and un-sentimental record of a disappearing way of life. A number of the terraced streets featured in these photographs, particularly those in Salford, were soon to fall victim to the wrecking ball. Children still play outside but today it is far more likely to be within a structured, dedicated space or under the watchful supervision of adults.

Paradise for some was playing out until dark and returning home tired, sated and happy. *Paradise Street* is celebration of that feeling, and of the lost art of playing outside.

Lucinda Gosling
Mary Evans Picture Library

A note about Mary Evans Picture Library:

Founded in Blackheath in 1964, Mary Evans Picture Library specialises in images of history and supplies photographs, illustrations, art and ephemera for use in all kinds of media, from television documentaries to museum exhibitions. In addition to its own unique archive, it represents some 350 different contributor collections belonging to photographers, museums, institutions, creators and specialists around the world.

London, 1960–1965 *John Gay*

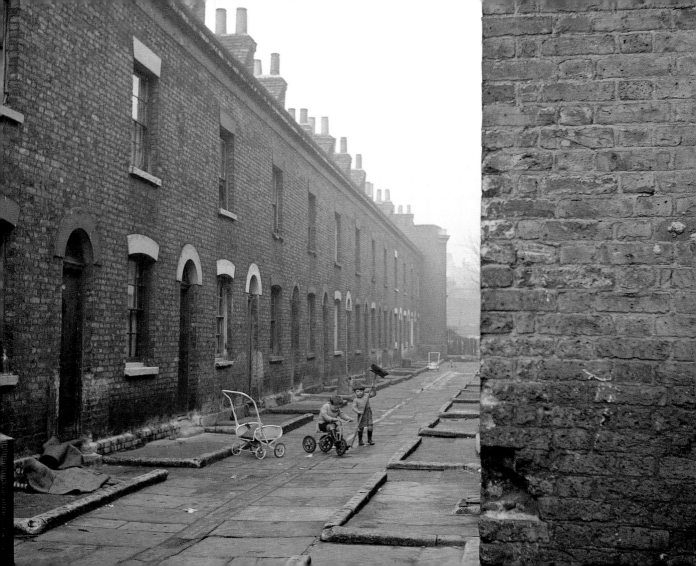

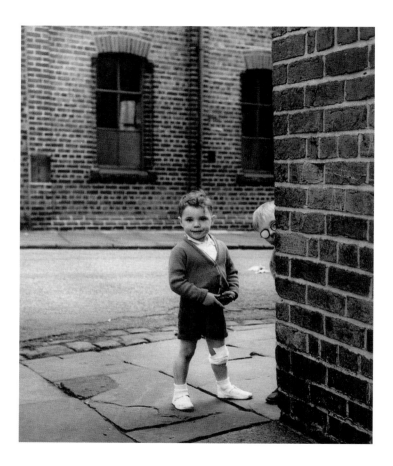

Wigan, Manchester, 1961 *Shirley Baker*

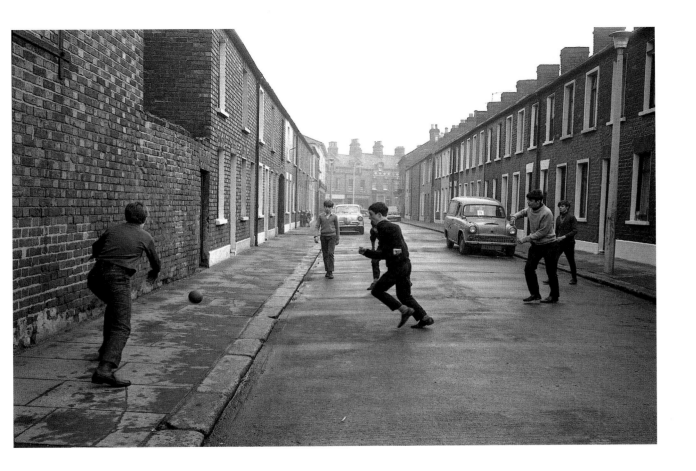

Falls Road, Belfast, 1969 *David Lewis-Hodgson*

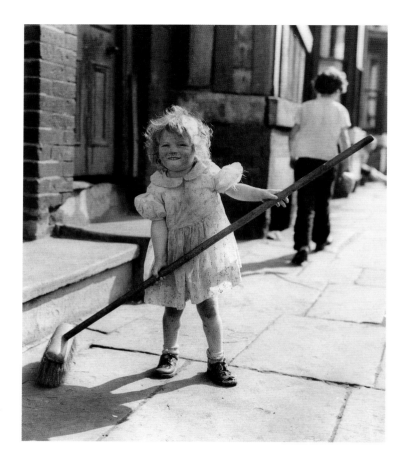

Unknown location, 1960s *Shirley Baker*

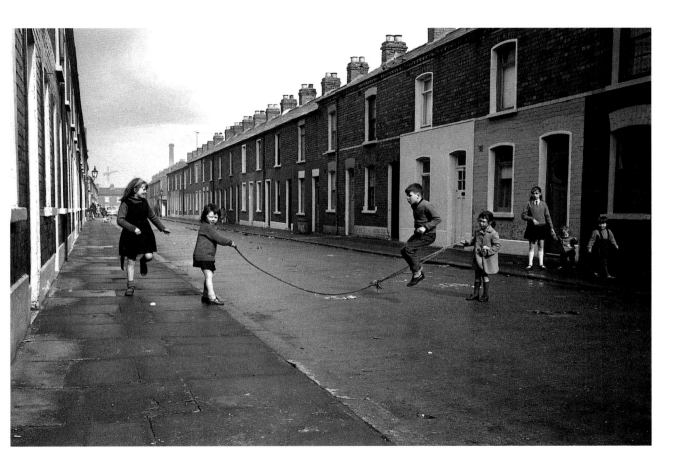

Belfast, 1969 *David Lewis-Hodgson*

Unknown location, 1930s *Margaret Monck*

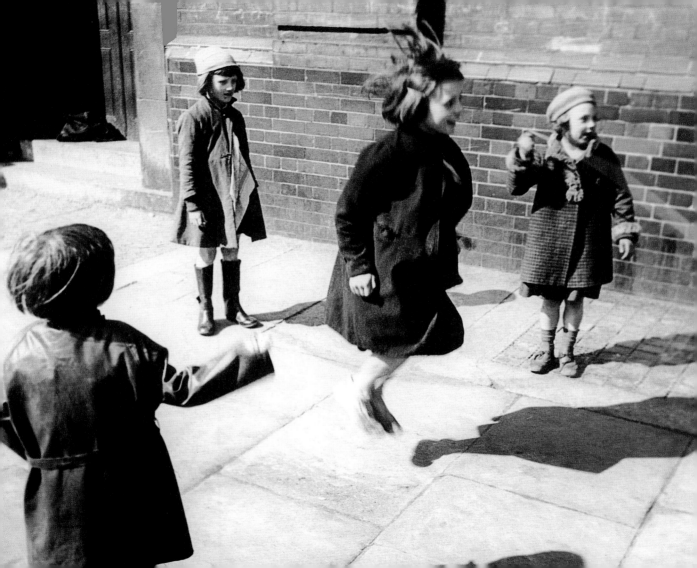

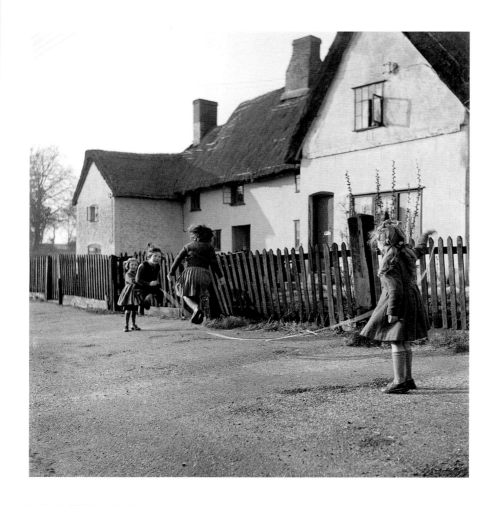

Suffolk, 1950s *John Gay*

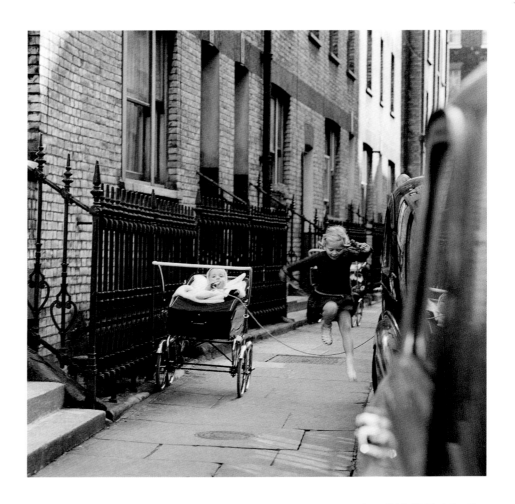

London, 1960–1965 *John Gay*

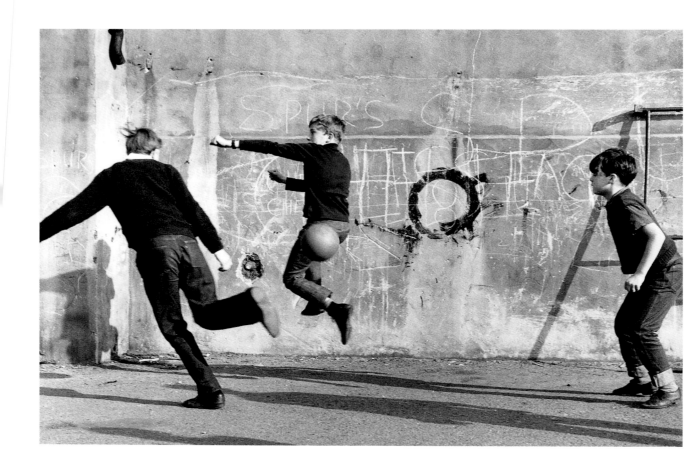

Balham, London, circa 1961 *Paul Kaye*

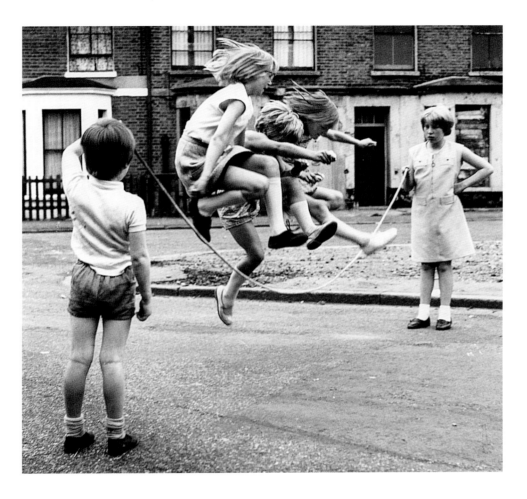

Balham, London, circa 1961 *Paul Kaye*

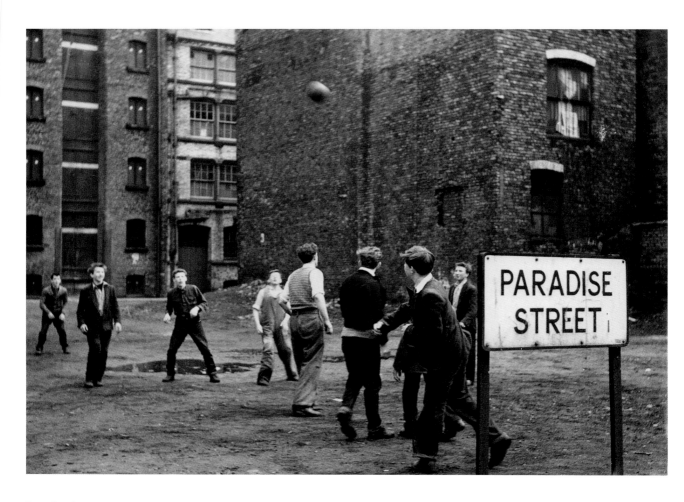

Paradise Street, Liverpool, 1950s *Unknown photographer*

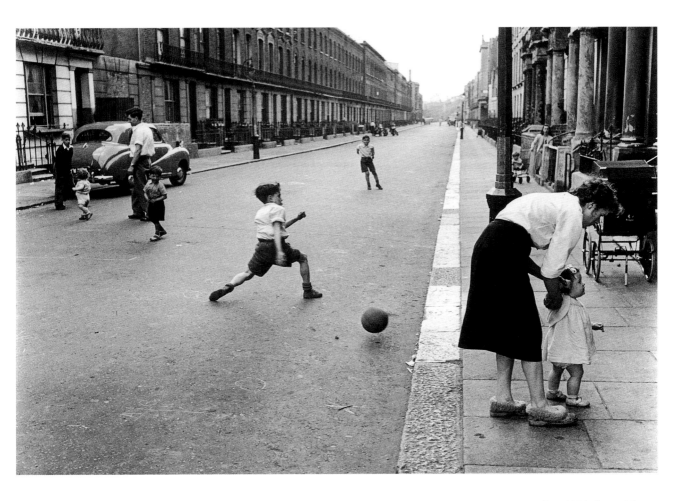

Southam Street, North Kensington, London, 1956 *Roger Mayne*

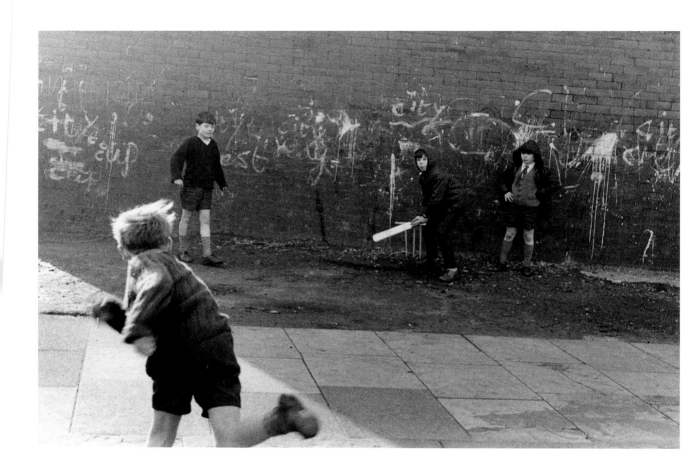

Unknown location, 1960s *Shirley Baker*

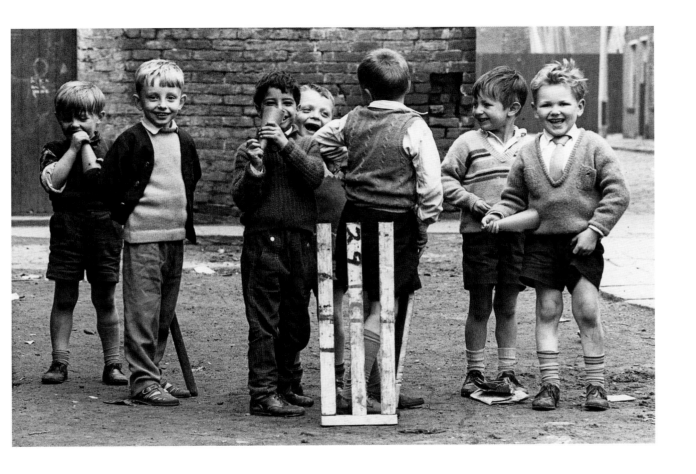

Salford, Manchester, 1964 *Shirley Baker*

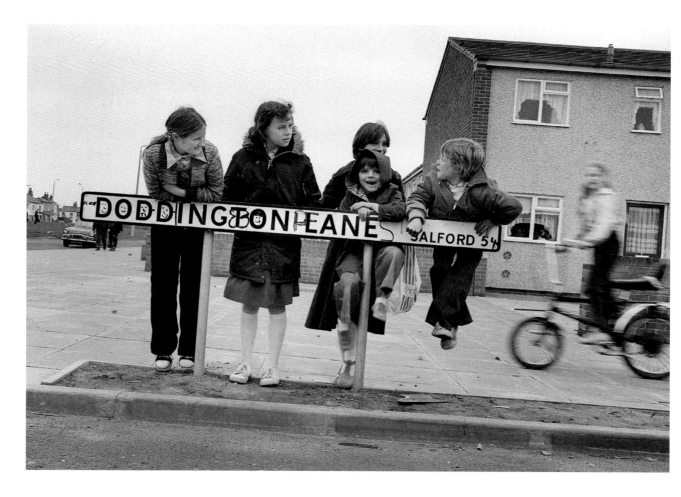

Doddington Lane, Salford, Manchester, 1970s *Martin O'Neill*

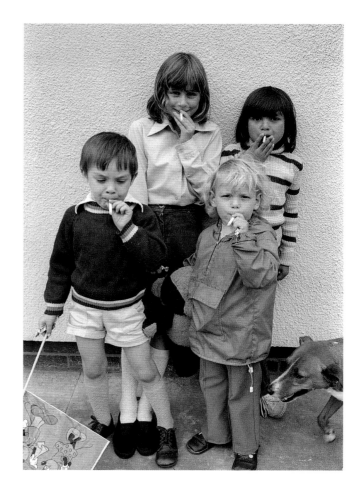

Unknown location, circa 1977 *Martin O'Neill*

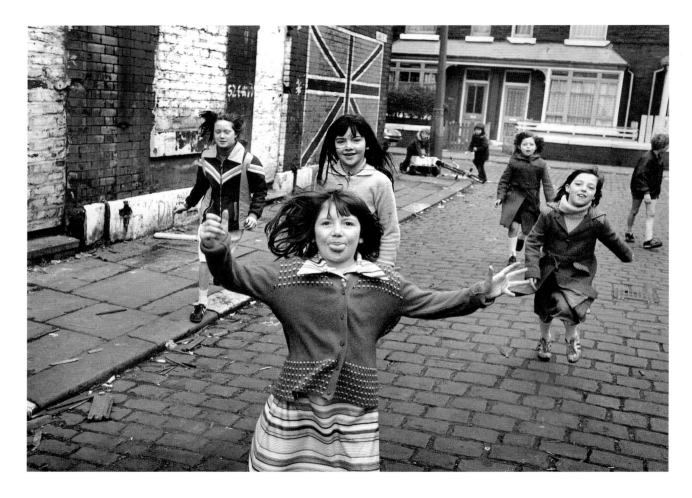

Weaste, Salford, Manchester, circa 1977 *Martin O'Neill*

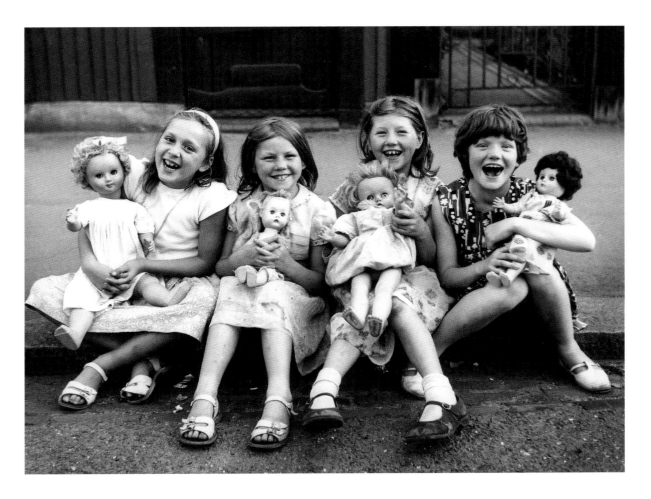

Balham, London, circa 1961 *Paul Kaye*

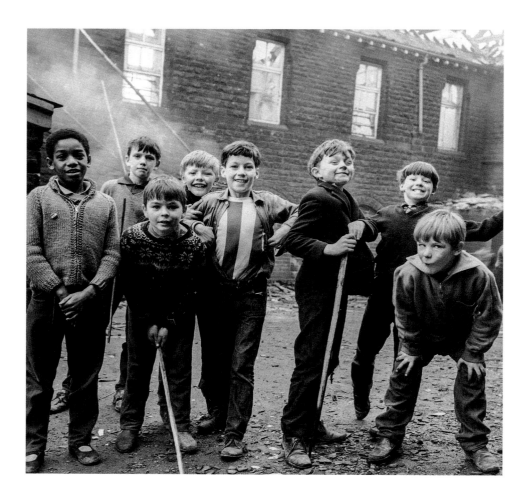

Sheffield, 1966 *Henry Grant*

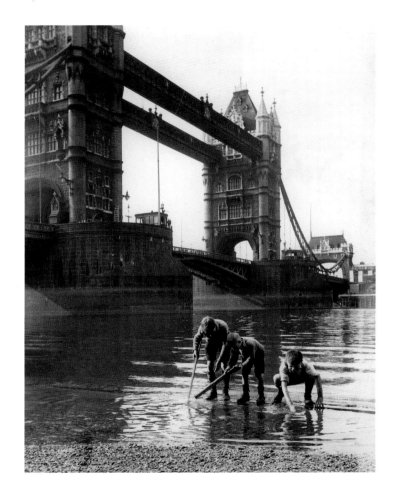

Tower Bridge, London, 1930 *Unknown photographer*

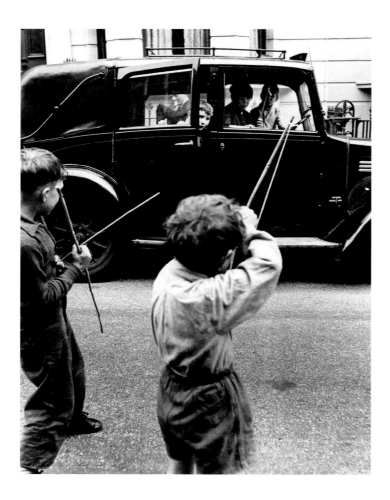

North Kensington, London, 1957 *Roger Mayne*

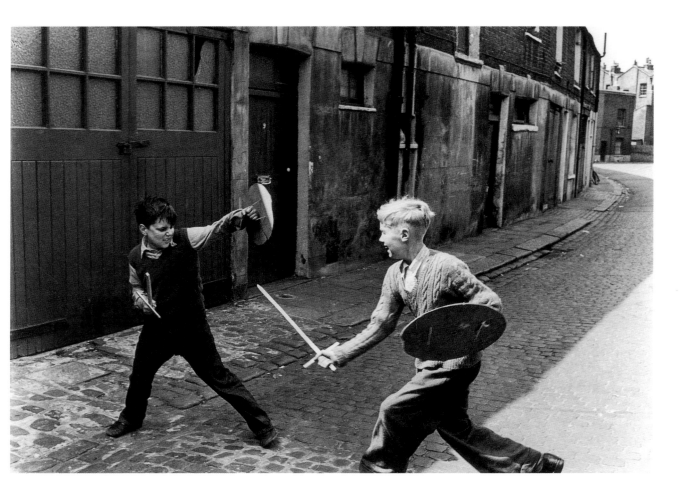

Addison Place, Holland Park, London, 1956 *Roger Mayne*

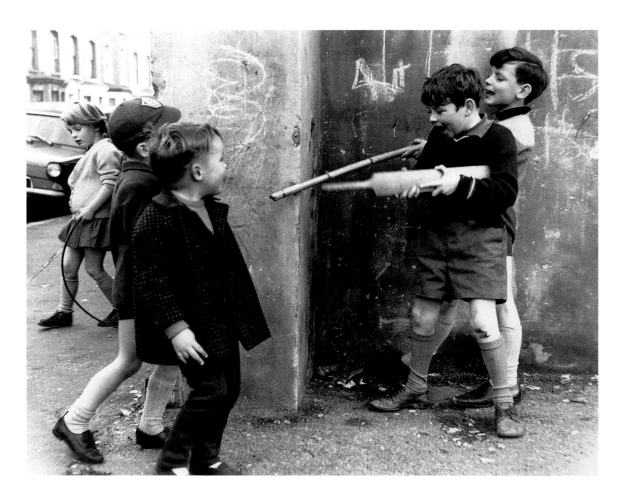

Balham, London, circa 1961 *Paul Kaye*

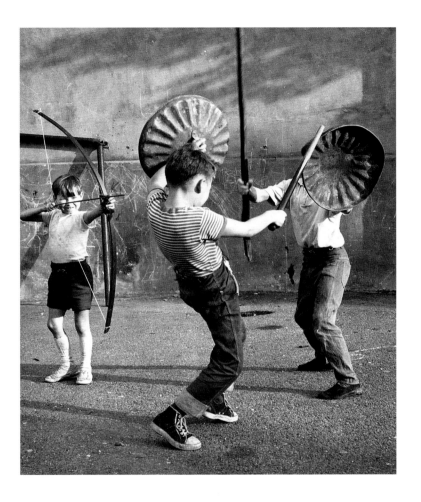

Balham, London, circa 1961 *Paul Kaye*

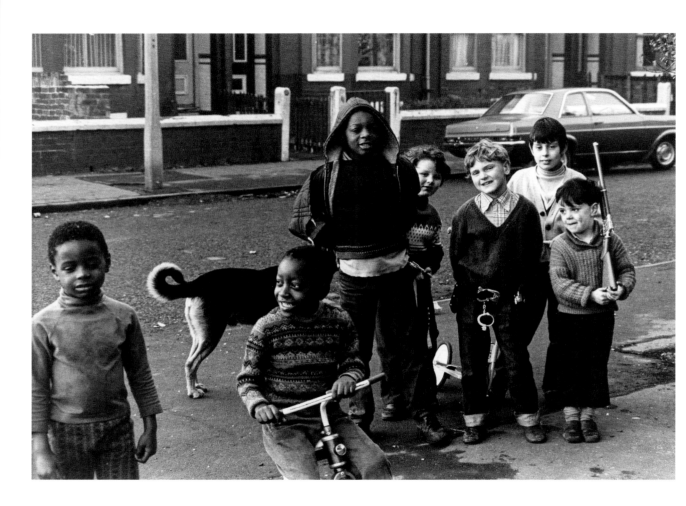

Unknown location, 1970s *Shirley Baker*

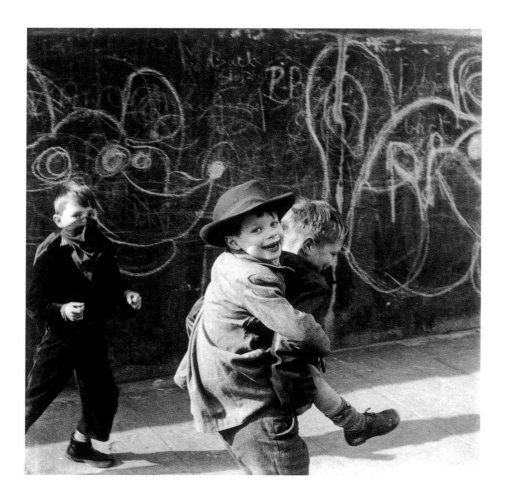

Hampden Crescent, Paddington, London, 1957 *Roger Mayne*

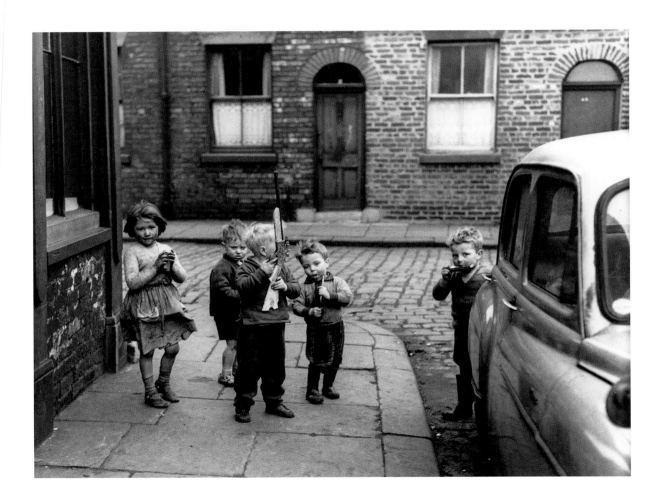

Manchester, 1961 *Shirley Baker*

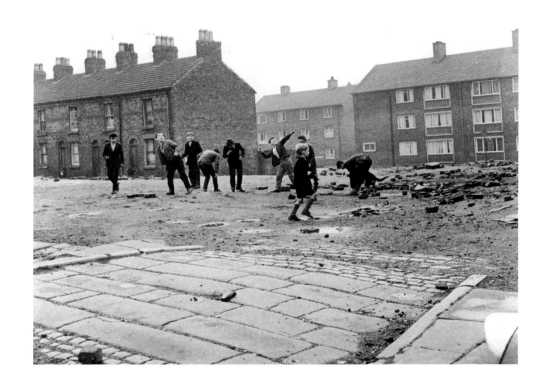

Unknown location, late 1960s *Henry Grant*

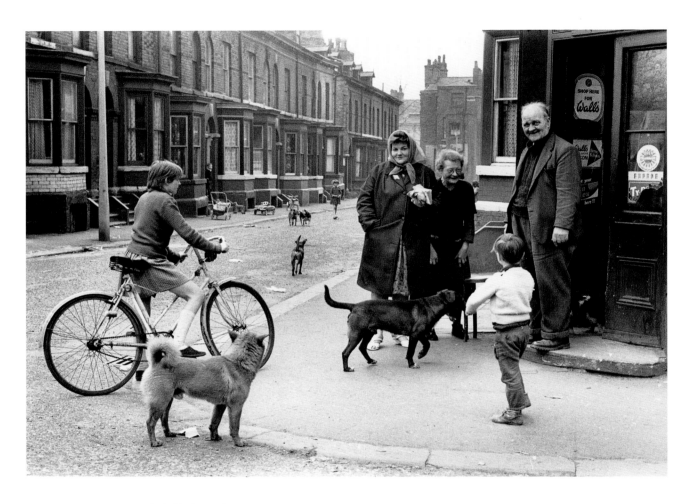

Moss Side, Manchester, 1968 *Shirley Baker*

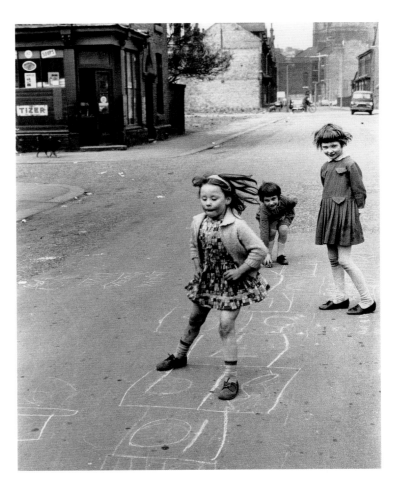

Moss Side, Manchester, 1968 *Shirley Baker*

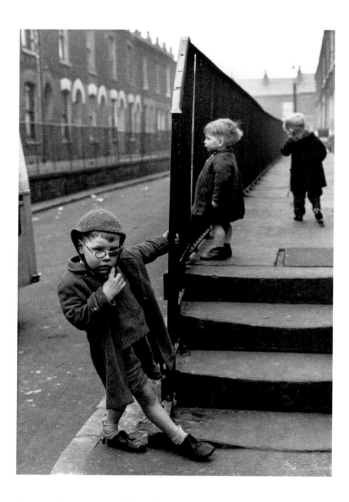

Salford, Manchester, 1964 *Shirley Baker*

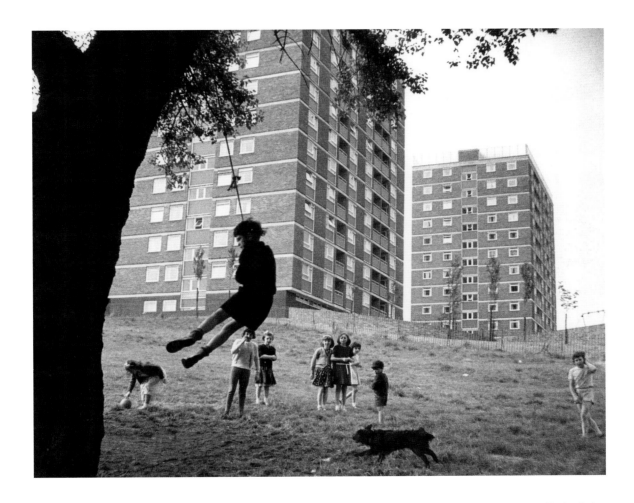

Unknown location, 1966 *Shirley Baker*

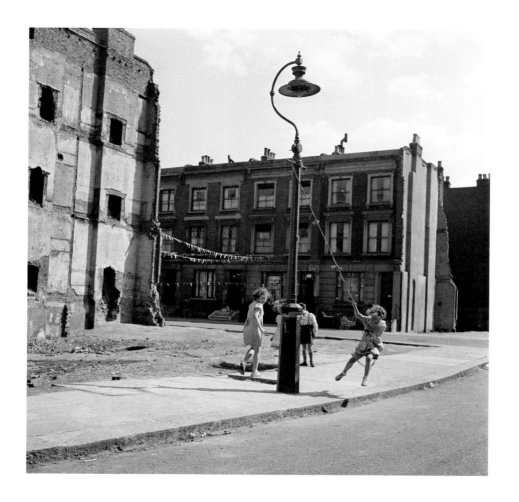

London, 1960–1965 *John Gay*

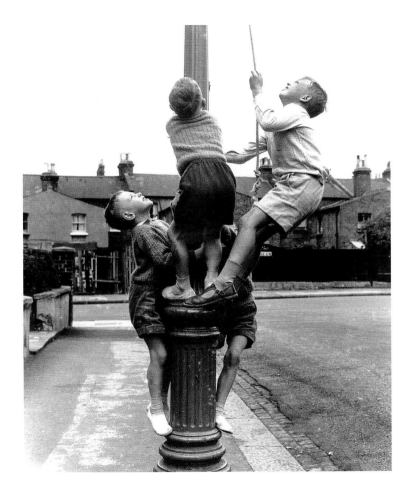

Balham, London, circa 1961 *Paul Kaye*

Milton Street, Belfast, 1969 *David Lewis-Hodgson*

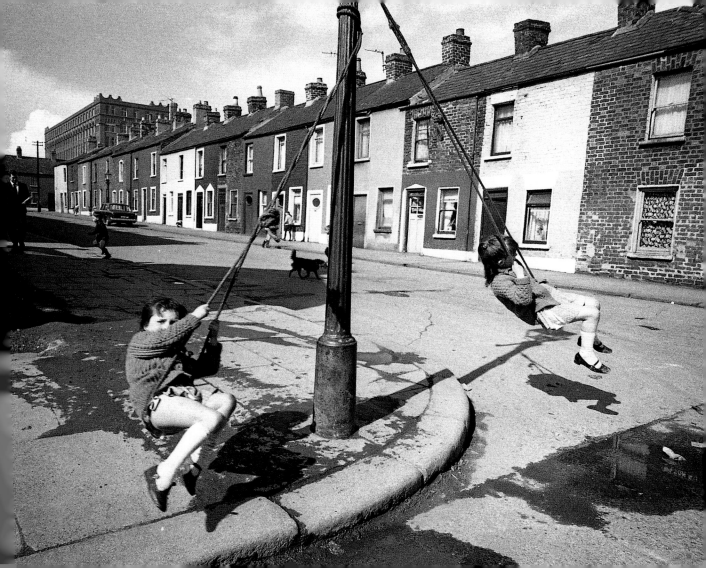

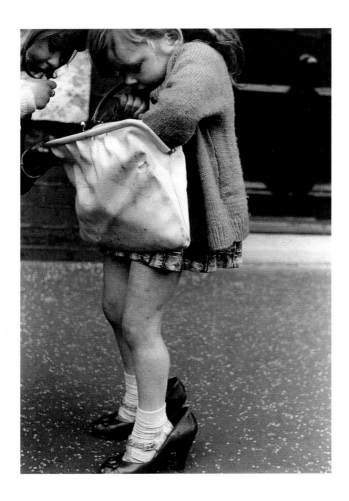

Unknown location, 1960s *Shirley Baker*

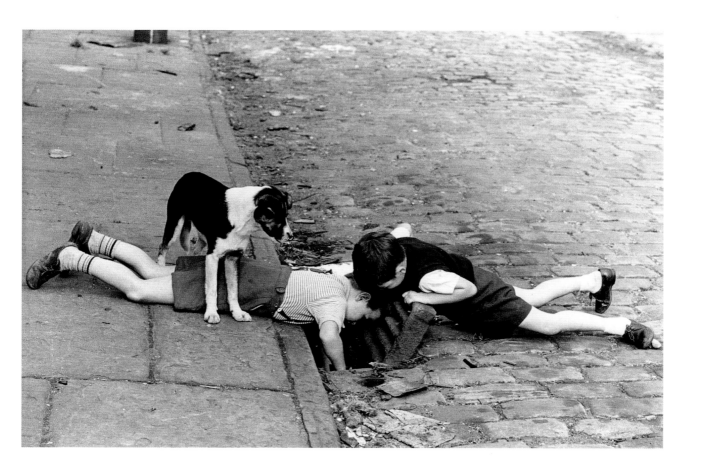

Manchester, 1963 *Shirley Baker*

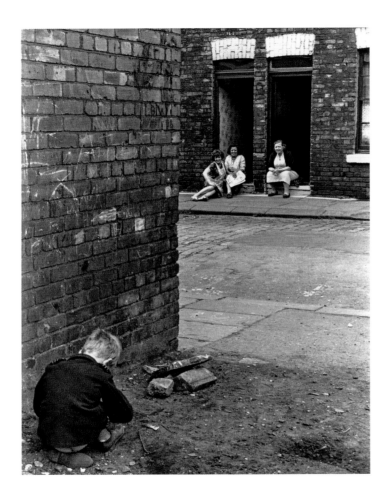

Salford, Manchester, 1964 *Shirley Baker*

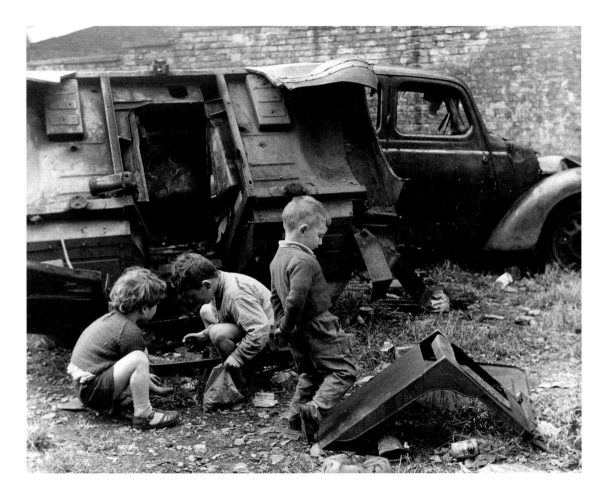

Unknown location, 1960s *Shirley Baker*

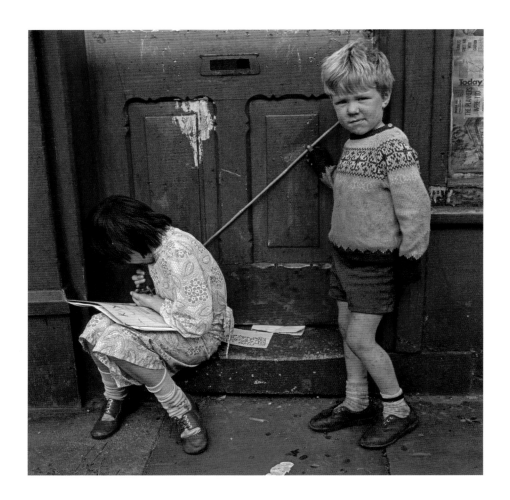

Stockton-on-Tees, County Durham, 1970s *Robin Dale*

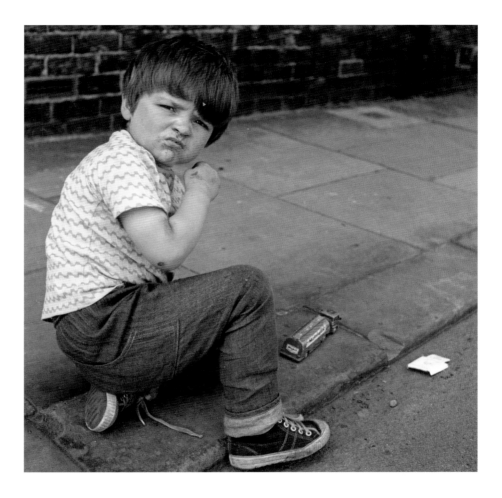

Middlesbrough, North Yorkshire, 1970s *Robin Dale*

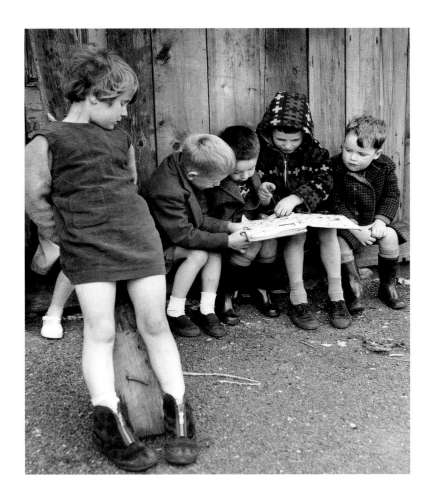

Balham, London, circa 1961 *Paul Kaye*

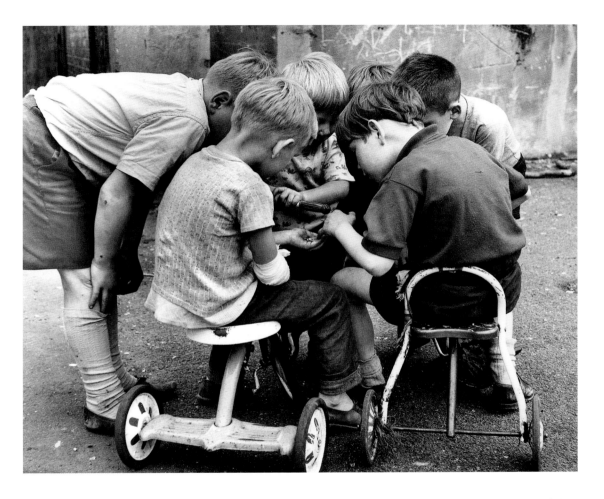

Balham, London, circa 1961 *Paul Kaye*

Balham, London, circa 1961 *Paul Kaye*

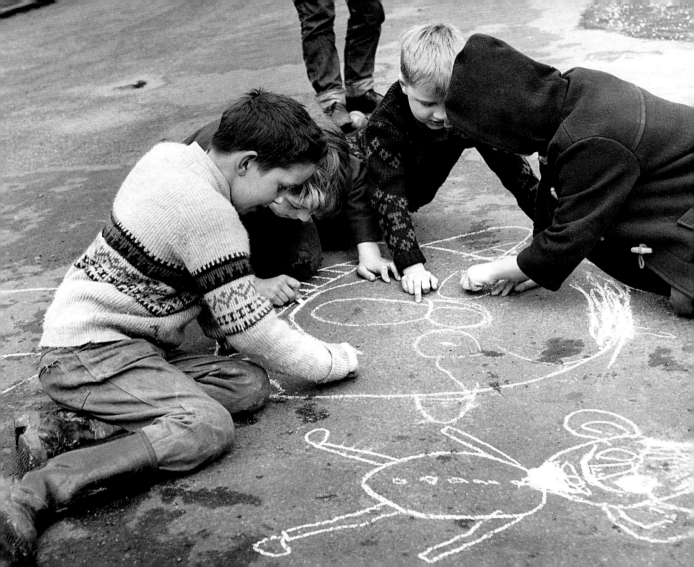

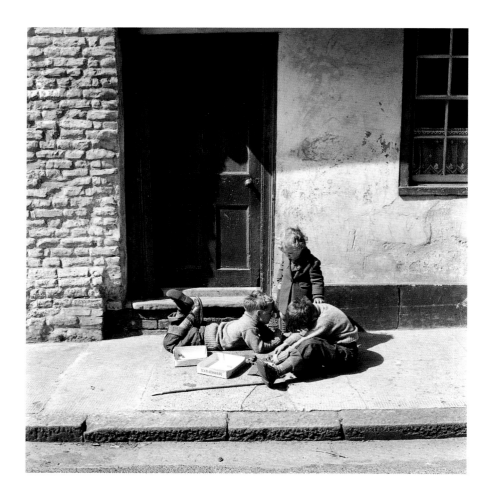

Unknown location, 1954 *John Gay*

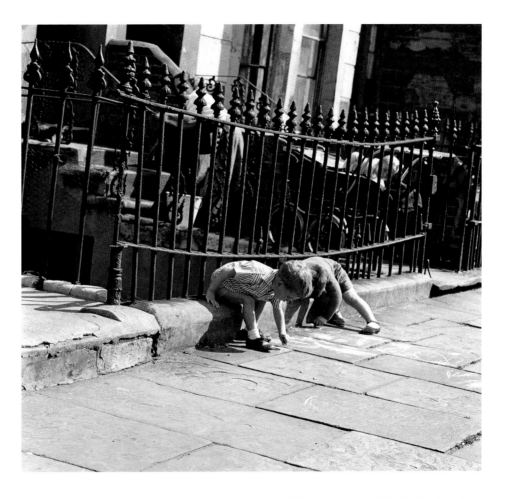

Paddington, London, 1962–1964 *John Gay*

Unknown location, 1950–1965 *John Gay*

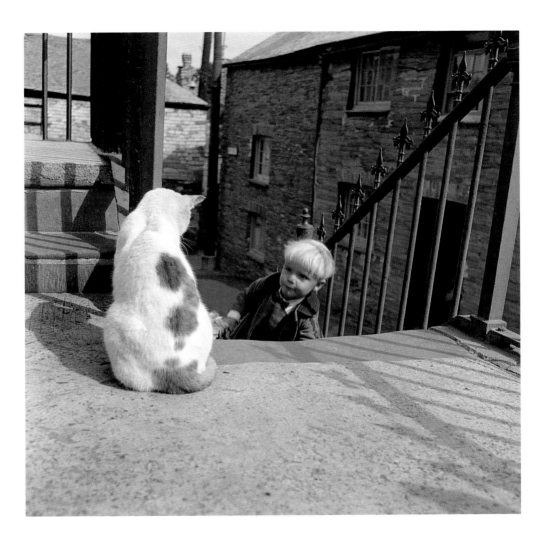

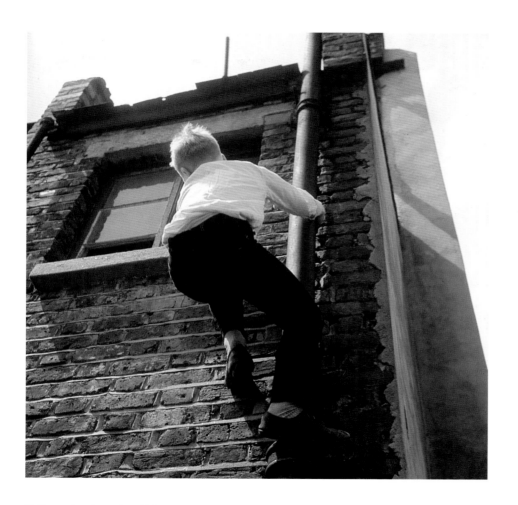

Balham, London, circa 1961 *Paul Kaye*

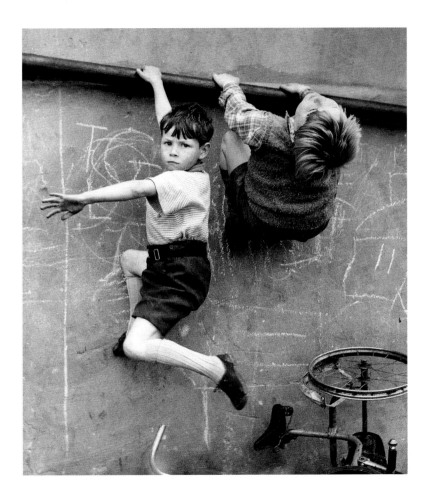

Balham, London, circa 1961 *Paul Kaye*

Balham, London, circa 1961 *Paul Kaye*

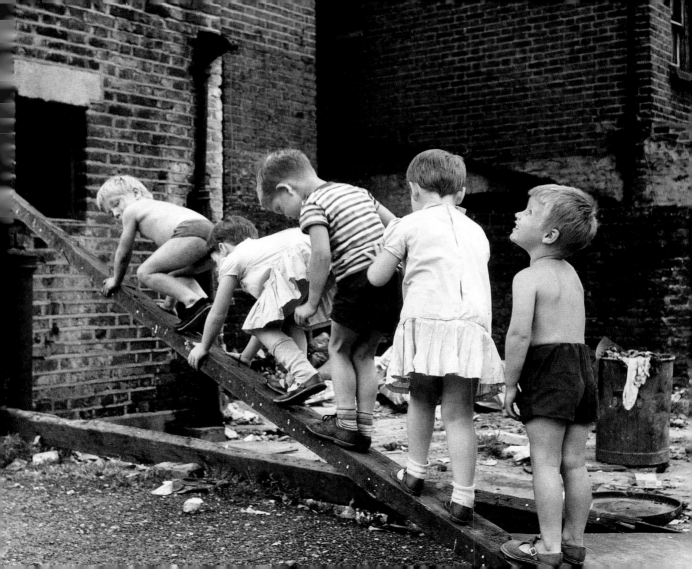

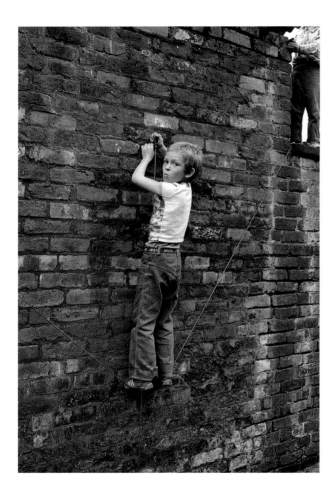

Eccles, Manchester, circa 1977 *Martin O'Neill*

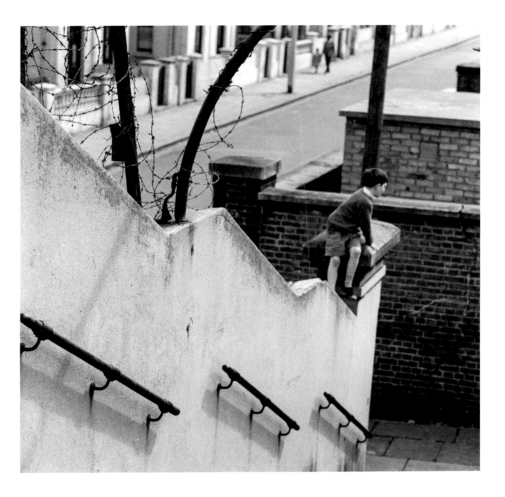

Paddington, London, 1962–1964 *John Gay*

Balham, London, circa 1961 *Paul Kaye*

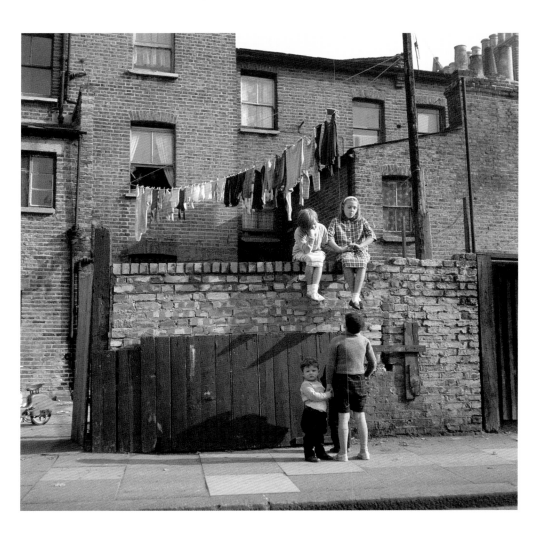

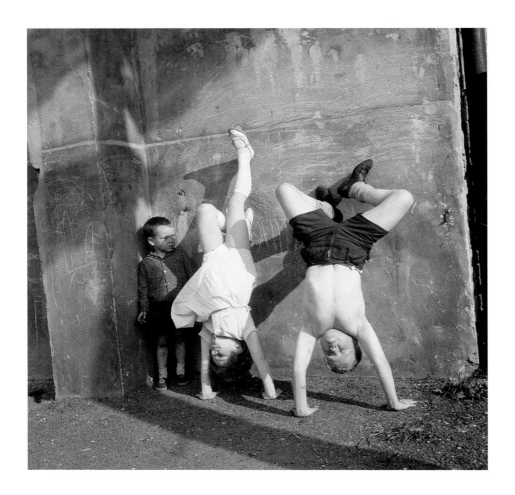

Balham, London, circa 1961 *Paul Kaye*

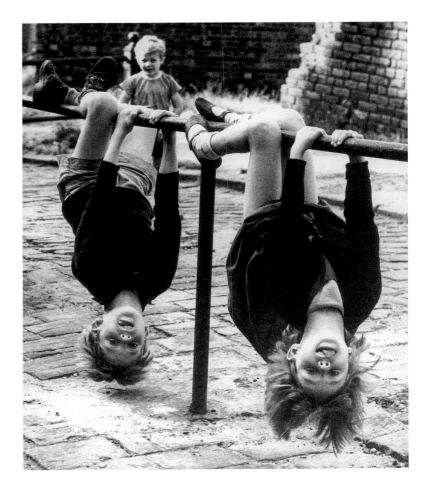

Stockport, Manchester, 1966 *Shirley Baker*

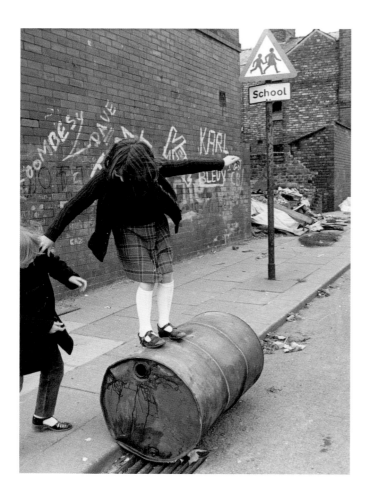

Unknown location, 1970s *Shirley Baker*

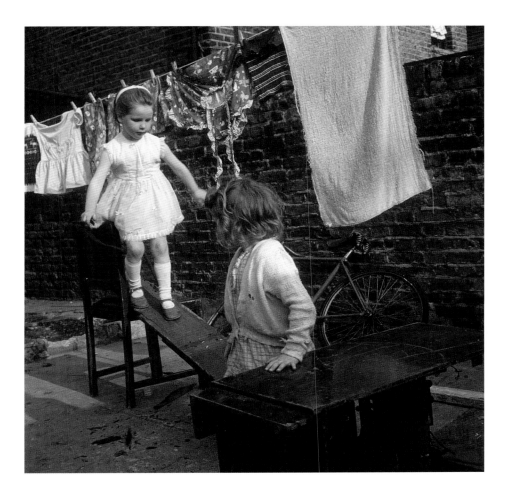

Balham, London, circa 1961 *Paul Kaye*

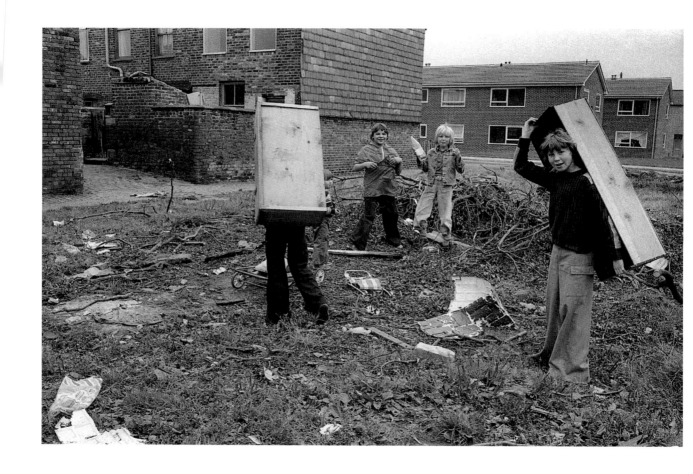

Eccles, Manchester, circa 1977 *Martin O'Neill*

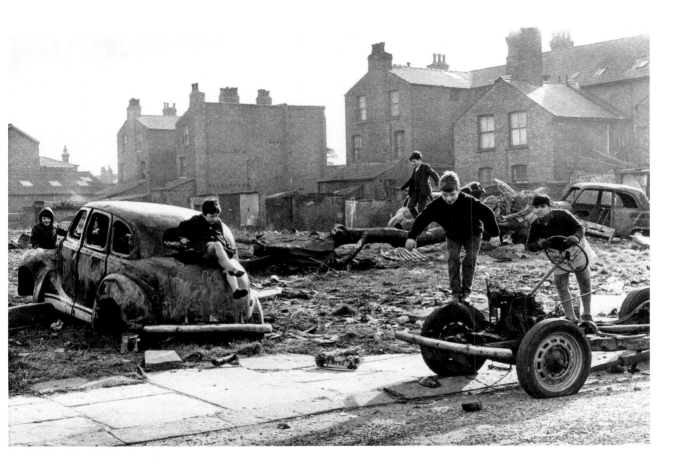

Moss Side, Manchester, 1968 *Shirley Baker*

Southbank, Middlesbrough, North Yorkshire, 1970s *Robin Dale*

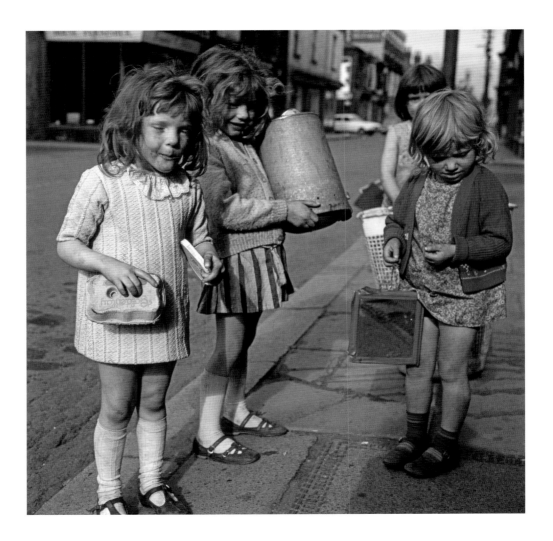

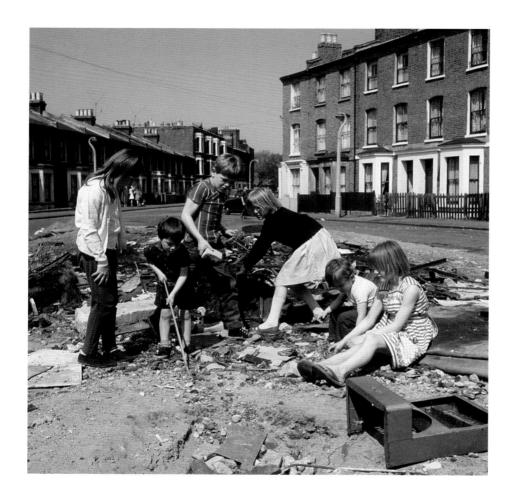

Balham, London, circa 1961 *Paul Kaye*

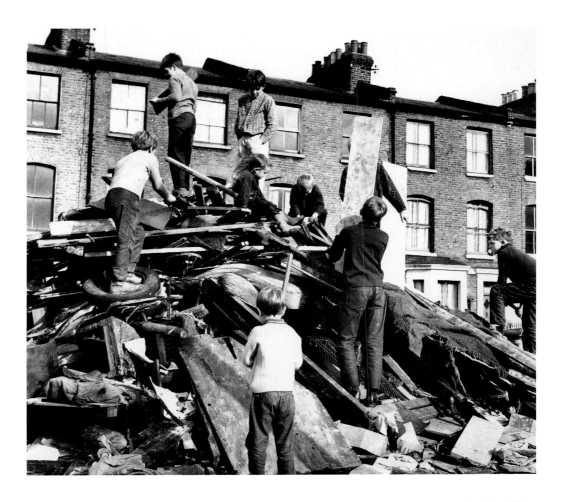

Balham, London, circa 1961 *Paul Kaye*

Unknown location, 1960s *Shirley Baker*

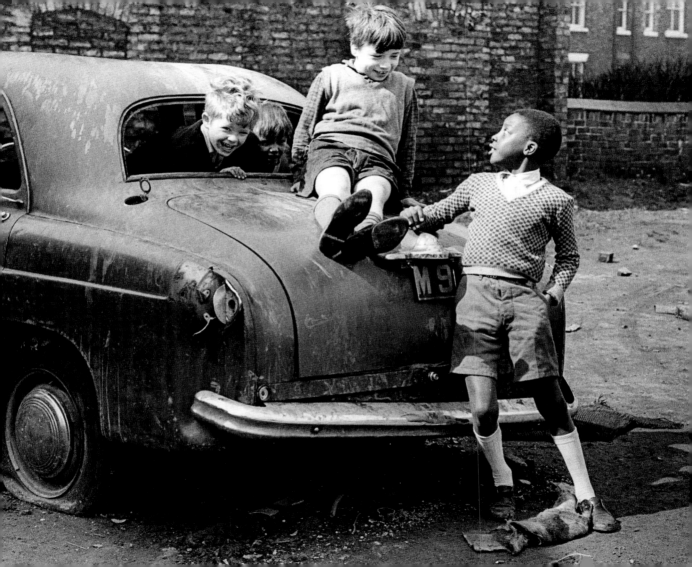

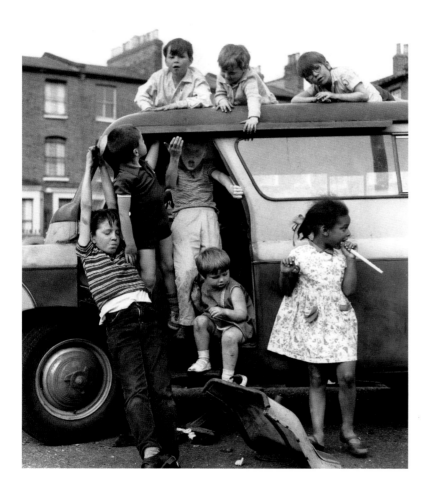

Balham, London, circa 1961 *Paul Kaye*

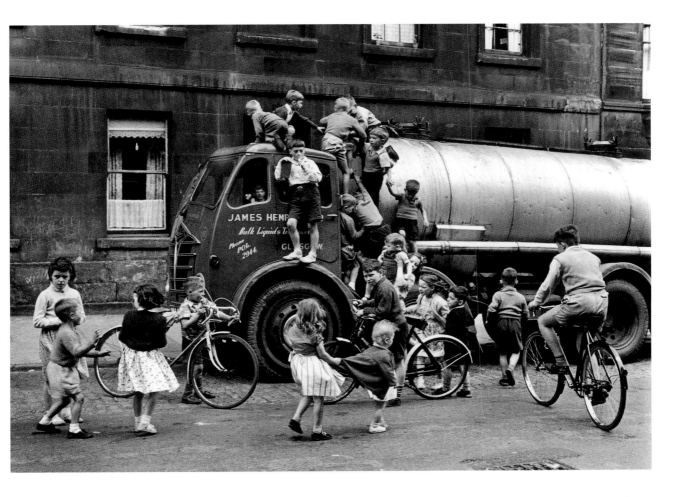

Glasgow, 1958 *Roger Mayne*

Unknown location, 1970s *Martin O'Neill*

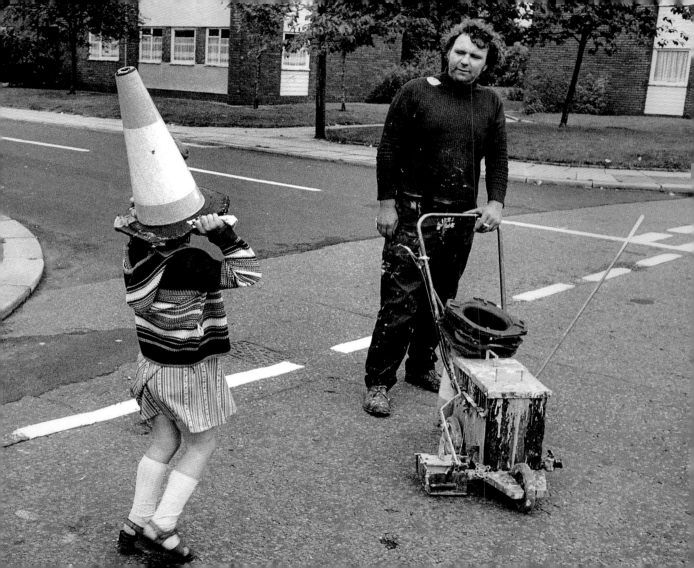

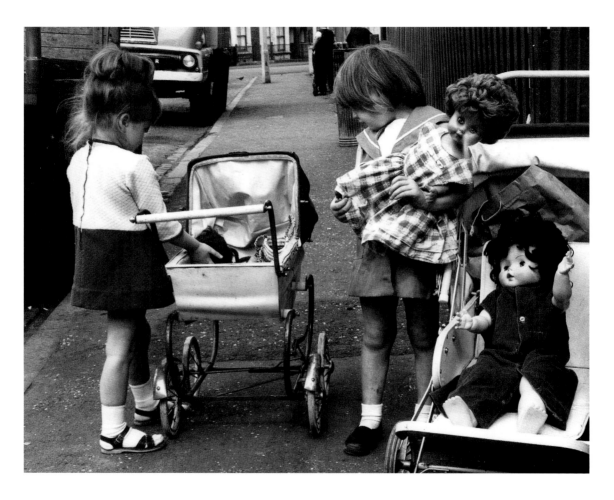

Balham, London, circa 1961 *Paul Kaye*

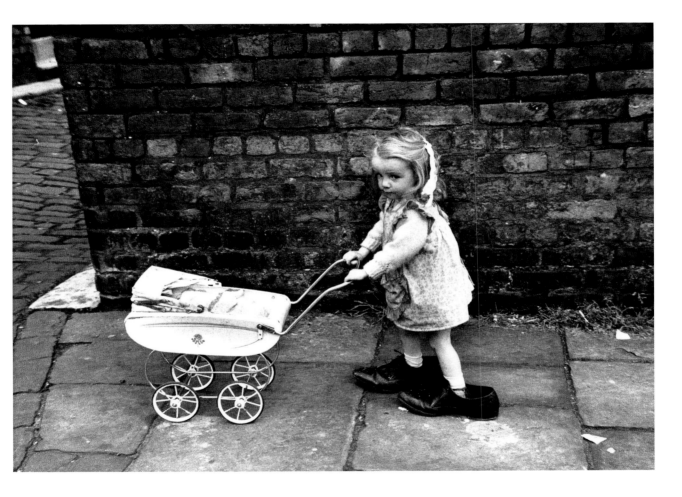

Manchester, 1966 *Shirley Baker*

Unknown location, 1960s *Shirley Baker*

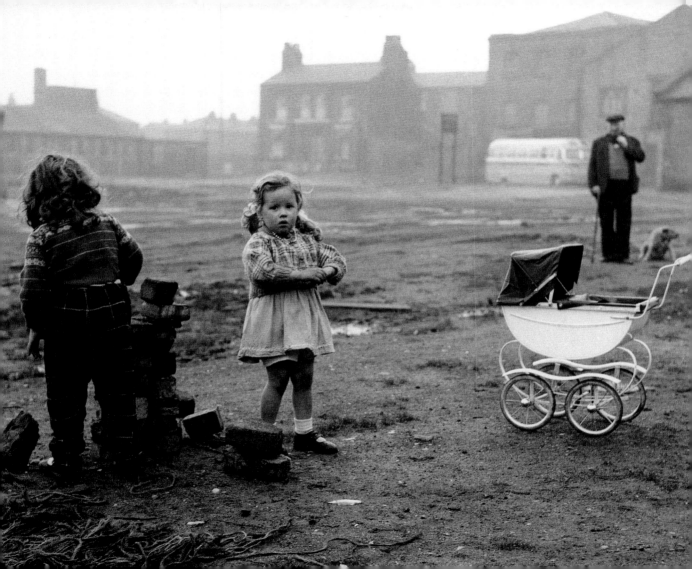

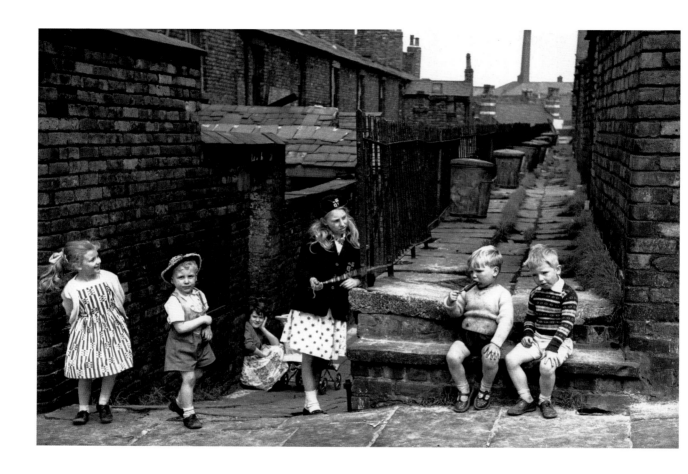

Salford, Manchester, 1962 *Shirley Baker*

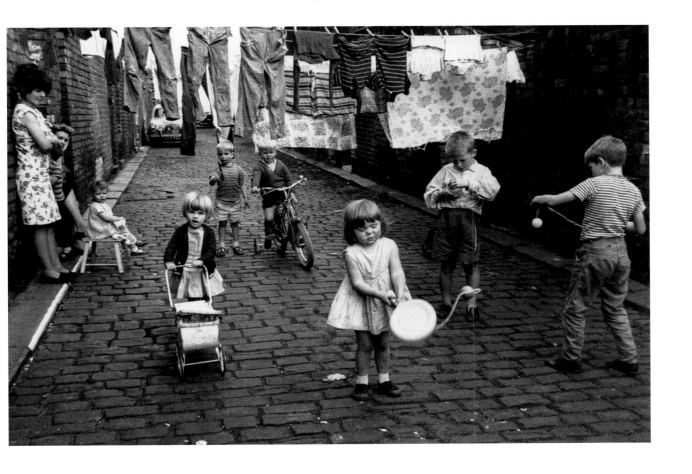

Chorlton-on-Medlock, Manchester, 1966 *Shirley Baker*

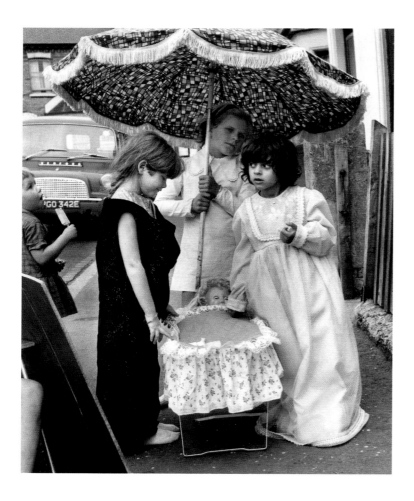

Balham, London, circa 1961 *Paul Kaye*

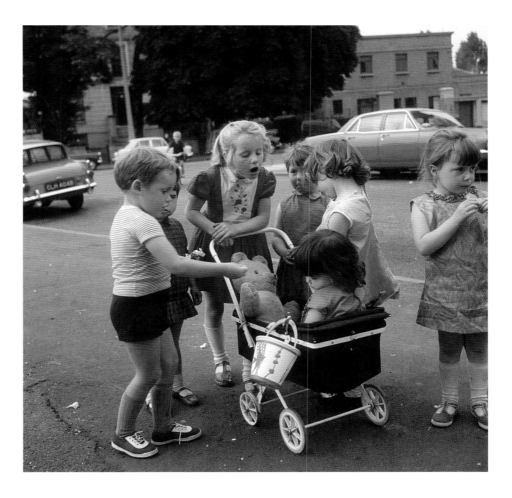

Balham, London, circa 1961 *Paul Kaye*

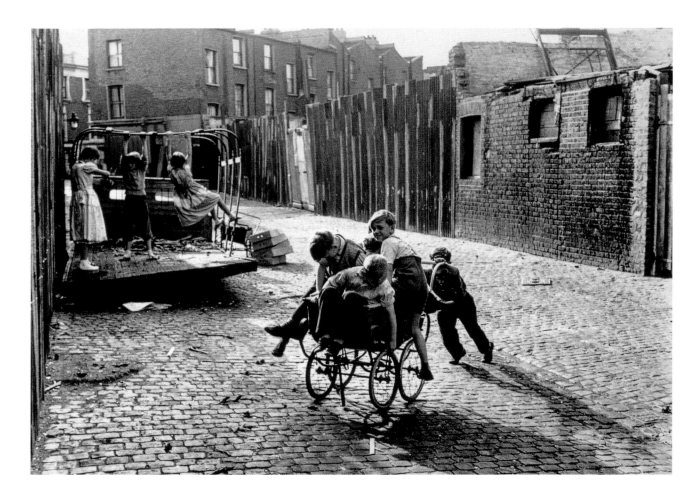

North Kensington, London, 1957 *Roger Mayne*

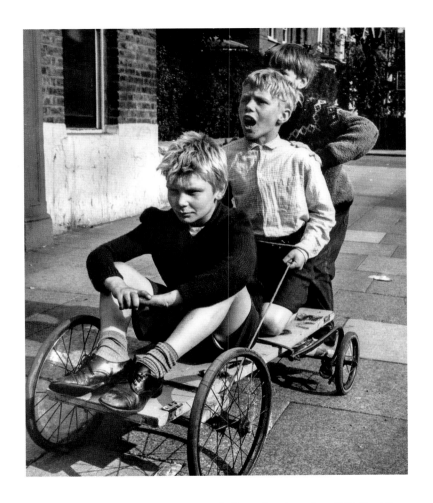

Balham, London, circa 1961 *Paul Kaye*

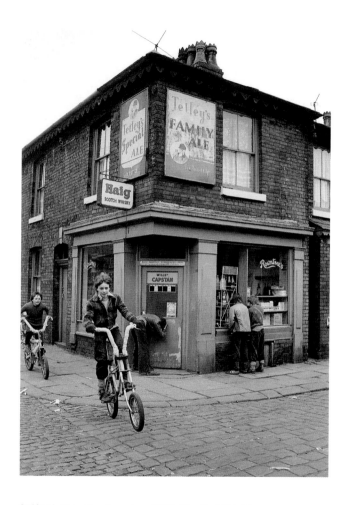

Salford, Manchester, circa 1977 *Martin O'Neill*

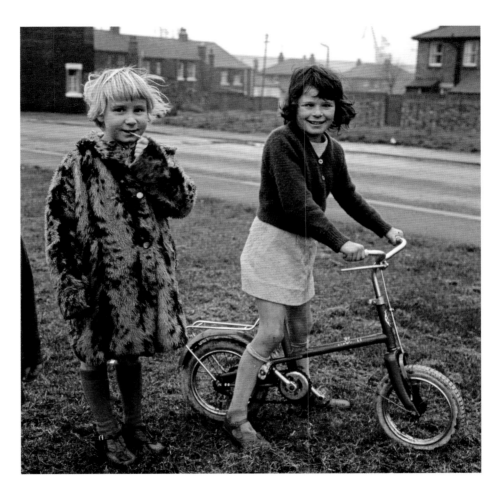

Haverton Hill, Stockton-on-Tees, County Durham, 1970s *Robin Dale*

Balham, London, circa 1961 *Paul Kaye*

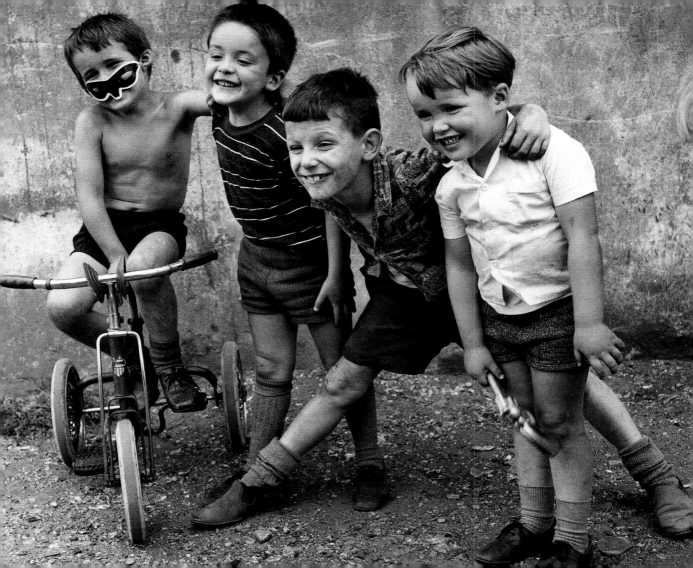

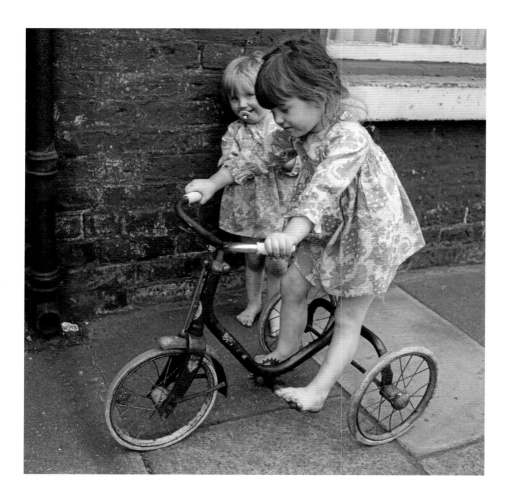

Thornaby-on-Tees, North Yorkshire, 1969 *Robin Dale*

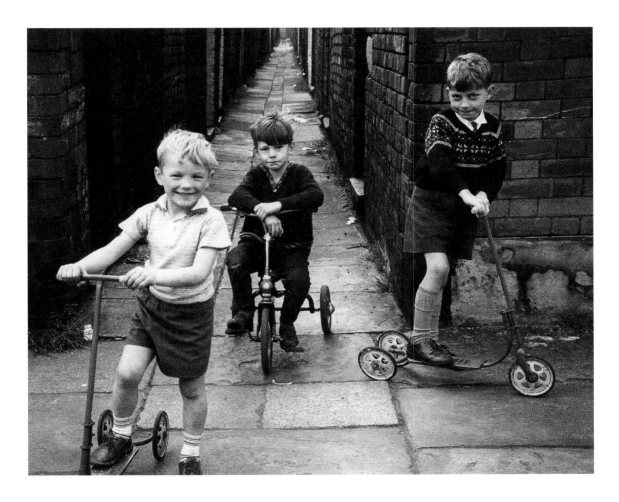

Unknown location, 1960s *Shirley Baker*

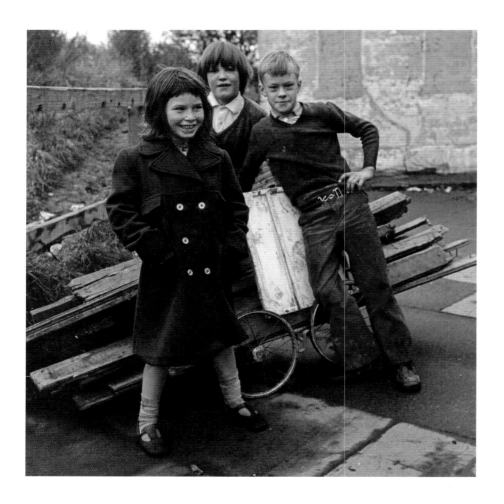

Haverton Hill, Stockton-on-Tees, County Durham, 1970s *Robin Dale*

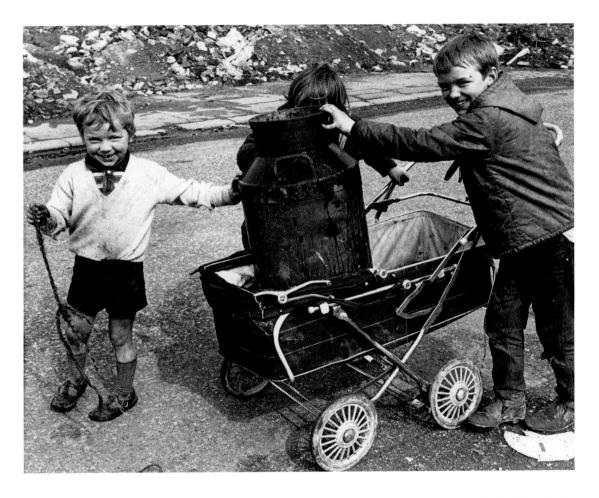

Unknown location, 1960s *Shirley Baker*

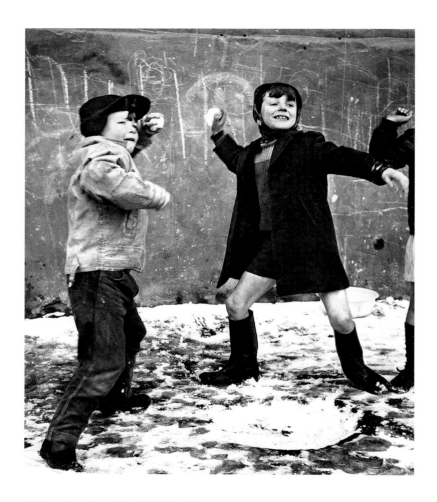

Balham, London, circa 1961 *Paul Kaye*

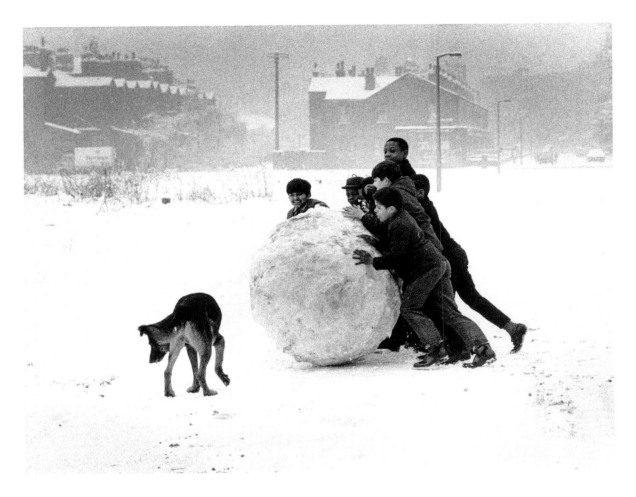

Manchester, 1968 *Shirley Baker*

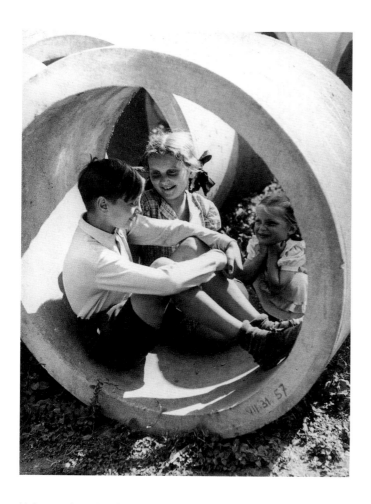

Unknown location, late 1950s *Unknown photographer*

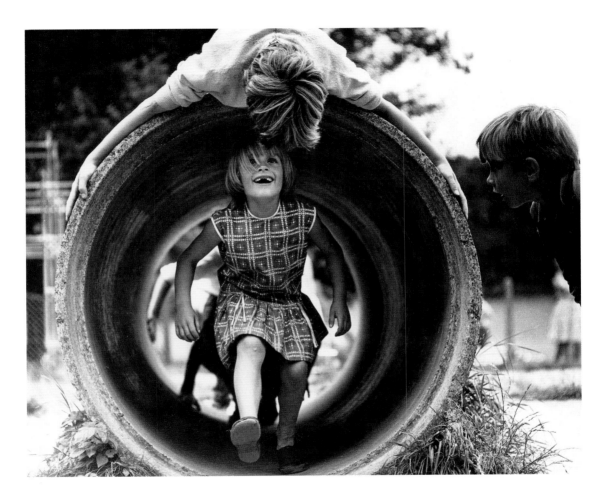

Unknown location, early 1970s *Tony Boxall*

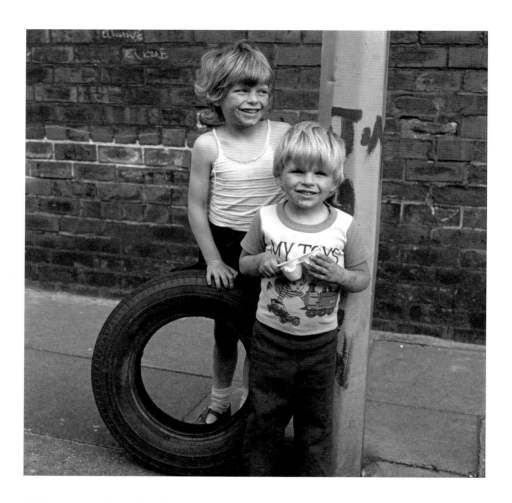

Middlesbrough, North Yorkshire, 1970s *Robin Dale*

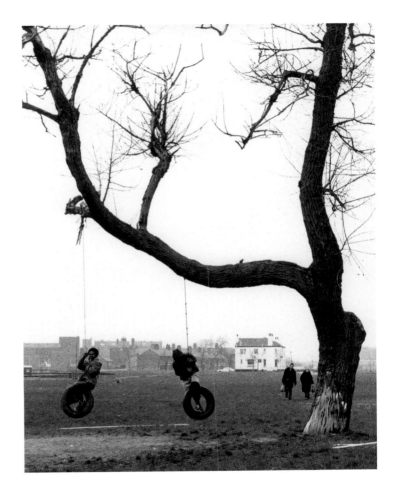

Unknown location, 1970s *Shirley Baker*

White Conduit Street, Islington, London, 1950s-1960s *John Gay*

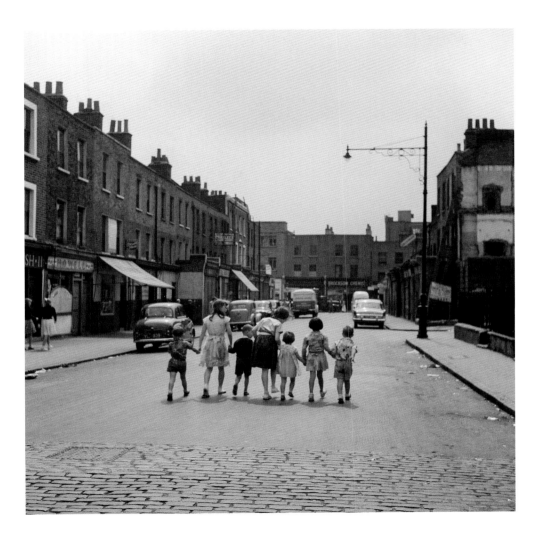

Paradise Street: The lost art of playing outside

First edition, published 2019
by Hoxton Mini Press, London
www.hoxtonminipress.com

Copyright © Hoxton Mini Press 2019
Design and sequence by Friederike Huber
Introduction text by Lucinda Gosling

All rights reserved

No part of this publication may be reproduced, stored in a
retrieval system, or transmitted in any form or by any means,
electronic, mechanical, photocopying, recording or otherwise,
without the prior written permission of the copyright owner.

ISBN: 978-1-910566-46-6

A CIP catalogue record for this book is available from the
British Library.

Printed and bound by
UAB BALTO print, Lithuania

MIX
Paper from
responsible sources
FSC® C107574
www.fsc.org

Image on page 4: Unknown location, circa 1930 *Unknown
photographer*

Credits:

Pages 4, 22, 106 © Mary Evans Picture Library
Pages 11, 18-19, 44, 58 © John Gay/English Heritage/Mary
Evans Picture Library
Pages 12, 14, 24-25, 36, 38, 40-43, 48-51, 71-72, 75, 81, 87,
89-91, 101, 103, 105, 109 © Estate of Shirley Baker/Mary
Evans Picture Library
Pages 13, 15, 47 © David Lewis-Hodgson/Mary Evans Picture
Library
Page 17 © Margaret Monck/Mary Evans Picture Library
Pages 20-21, 29, 34-35, 45, 54-57, 62-65, 69-70, 73, 78-79, 82,
86, 92-93, 95, 99, 104, image on front cover © The Paul Kaye
Collection/Mary Evans Picture Library
Pages 23, 32-33, 37, 83, 94 © Roger Mayne Archive/Mary
Evans Picture Library
Pages 26-28, 66, 74, 85, 96 © Martin O'Neill/Mary Evans
Picture Library
Pages 30, 39 © Henry Grant/Mary Evans Picture Library
Page 31 © Imagno/Mary Evans Picture Library
Pages 52-53, 77, 97, 100, 102, 108 © Robin Dale/Mary Evans
Picture Library
Pages 59, 61, 67, 111 © John Gay/Historic England/Mary
Evans Picture Library
Page 107 © Tony Boxall/Mary Evans Picture Library